Color Theory

By Patti Mollica

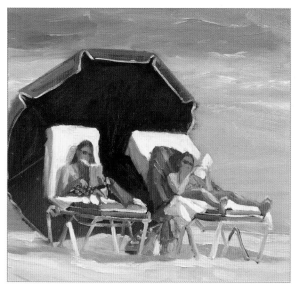

Beach Bums, acrylic

WalterFoster

www.walterfoster.com

Associate Publisher: Rebecca J. Razo
Project Manager: Elizabeth Gilbert
Art Director: Shelley Baugh
Senior Editor: Amanda Weston
Associate Editor: Stephanie Meissner
Production Designers: Debbie Aiken, Amanda Tannen
Production Manager: Nicole Szawlowski
Production Coordinator: Lawrence Marquez
Production Assistant: Janessa Osle

www.walterfoster.com
Walter Foster Publishing, Inc.
3 Wrigley, Suite A
Irvine, CA 92618

10 9 8 7 6 5 4 3 2 1

Table of Contents

Introduction

Color is a universal gift of beauty. Because it requires no effort to perceive and enjoy it, we often take it for granted. However, its absence in our lives is unthinkable. Consider a world wherein brilliant sunsets, vivid flower gardens, shimmering butterflies, and tropical fish shed their multicolored hues and morphed into monochromatic shades of gray. The experiences that we love and live for would change drastically! Would we still plant flower beds? Bird watch? Sight see? The implications are immense; such is our love affair with color.

But what exactly is color? More specifically, how do we understand it, organize it, and harness its power in a manner that helps us create, communicate, and express? The purpose of this book is to both introduce and explore concepts of color theory, particularly as they relate to oil and acrylic painting. From the electromagnetic spectrum to pigment properties, color schemes, and color psychology, we will cover a wide range of valuable topics that are sure to bring your understanding of color to a new level. The more you know about color organization and mixing, the more you will be equipped to achieve your unique artistic goals.

So let's jump into the world of color and learn about this most fascinating phenomenon!

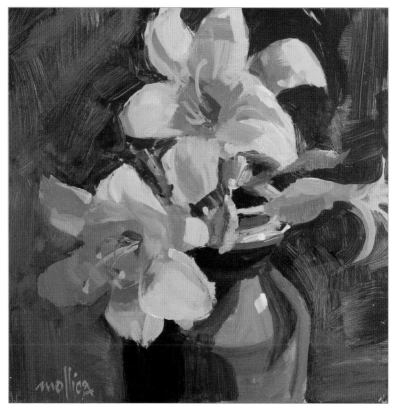

Lilies, acrylic

Getting Started

In addition to basic color concepts, this book covers pigment characteristics and color mixing techniques for oil and acrylic paints. Below is a short guide for gathering the materials you may need to follow along with the book. It's always a good idea to purchase the best you can afford; high-quality materials have a long life span and yield brighter colors. In particular, I suggest that you choose artist-grade over student-grade paints, as they contain more pigment and less filler for better coverage and richer results.

Materials Checklist:
- Paints (oil or acrylic)
- A range of brush shapes and sizes (I prefer high-quality synthetic)
- Mixing palette
- Palette knife
- Jars of water (for acrylic)
- Solvent and linseed oil (for oil)
- Mediums
- Paper towels or rags

Shown at right is my basic palette of acrylic colors in my preferred layout. From left to right: ultramarine blue, cerulean blue, phthalo green, cadmium lemon yellow, cadmium yellow medium, cadmium orange, cadmium red light, cadmium red deep, quinacridone magenta, yellow ochre, burnt sienna, burnt umber, and middle gray. Titanium white is at far left.

artist's tip

For artists who like to work with transparent glazes, below are a few helpful transparent/semi-transparent equivalents:
- Ultramarine blue: anthraquinione blue
- Cadmium lemon yellow: hansa yellow light
- Cadmium yellow medium: hansa yellow medium
- Cadmium red medium: naphthol red
- Titanium white: zinc white

Color & Art History

Thousands of years ago, humans realized that using pigments to communicate was more effective than scratching images into trees or stone walls. What follows is a short history of color and its contributions to various civilizations over the years.

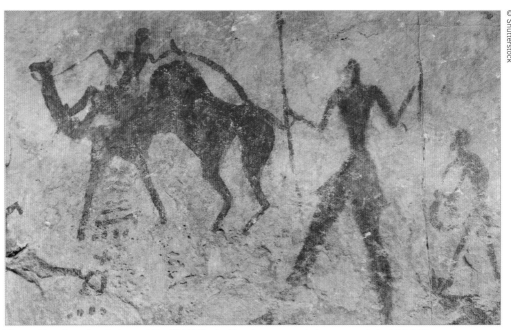

The prehistoric rock paintings of Tassili N'Ajjer in Algeria were created over a period of 10,000 years.

The very first "paint" was made from charcoal or earth pigments such as limonite, hematite, red ochre, yellow ochre, umber, burnt bones, and white calcite, which was then ground up into a paste and mixed with binders of spit, blood, urine, vegetable juices, or animal fat. Humans applied this paint using twigs, feathers, or animal hair—often they even blew the paint through hollow bones to produce an "airbrush" effect.

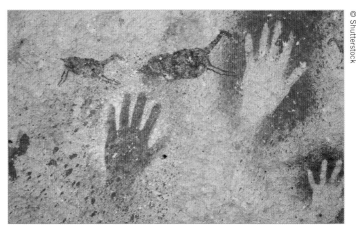

Cueva de los Manos in Patagonia, Argentina, features colorful and lively ancient cave paintings that date between 9,500 and 13,000 years old. Many of the hands are stenciled, suggesting the use of an airbrush technique.

The Greeks and Romans discovered the use of wax, resin, and eggs as a binding vehicle, while the Egyptians discovered and used earth pigments such as malachite (green), azurite (blue), realgar (red-orange) madder, and carmine lake (red). The Middle Ages brought the discovery of ultramarine (blue), which was used extensively in representations of the Virgin Mary's garments as a symbol of purity. By the 15th century, walnut and linseed oil began to replace egg as a binder, paving the way for a far more versatile medium: oil paint. This ushered in a new era of advancements in an artist's ability to depict realism in perspective, picture-plane depth, luminosity, enhanced color, and more nuanced simulations of light and shadow.

The 19th century, which marked the beginning of the Modern Age, brought both the inventions of watercolor and the collapsible tin paint tube, revolutionizing the painting world and leading to a new era of color. No longer bound by grinding their own pigments, artists founded color-based movements such as Impressionism and Fauvism. Simultaneously, new and more vivid pigments burst onto the scene as a reaction to this new era of color liberation. The Contemporary Age, starting in 1900, brought artists the invention of both water-based paint (acrylics) and synthetic pigments, touted for their unparalleled brilliance of hue, lightfastness, and translucency.

Due to developments and discoveries over the years, artists today have such versatility at their fingertips! We have the ability to express ourselves in tried-and-true mediums, and yet we have the exciting opportunity to blaze new trails by combining old and new materials in ways that have not been realized. What a fabulous time to be an artist!

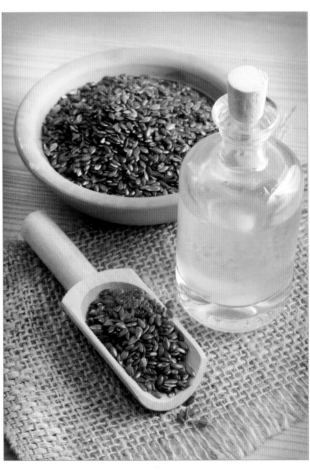

Pressed from flax plant seeds, linseed oil surfaced in the 1400s as a binder for pigments and is still a popular choice today.

What is Color?

In the late 1600s, Sir Isaac Newton (1642–1727) conducted and published a series of experiments involving prisms, light, and color, which form the basis of our current understanding of color. These experiments involved refracting white light through a prism—a simple triangular glass object that separates light waves into individual colors. The results revealed that light could actually be broken down into seven individual colors: red, orange, yellow, green, blue, indigo, and violet. Until this discovery, it was assumed that a prism somehow "colored" the light passing through it. To prove this wrong, Newton reversed the process: He projected the colors back into the prism, which resulted in pure white light. Artists and scientists alike were amazed by this breakthrough discovery that *light is the source of all color.*

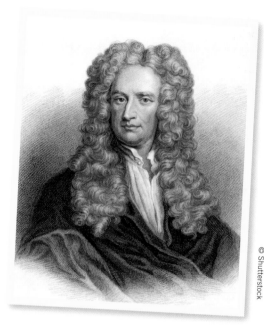

Scientist Sir Isaac Newton provided the foundation for color theory as we understand it today.

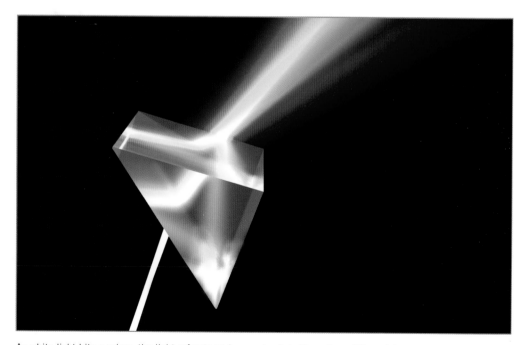

As white light hits a prism, the light refracts and separates into the colors of the rainbow.

Light is made of electromagnetic waves produced by a light source, such as a candle, an electric light bulb, or the sun. These waves exist in varying lengths, which correspond to the different colors we see. For example, red is the longest wavelength, and violet is the shortest. The colors that we see when light strikes an object are the result of certain wavelengths (individual colors) being absorbed by the object while other wavelengths are being reflected back to us. Those reflected back to us are the colors that we see. They are focused by the lens of our eye and projected onto our retina. Because physiology differs from one person to the next, we each perceive color slightly differently. This makes our perception of color somewhat subjective.

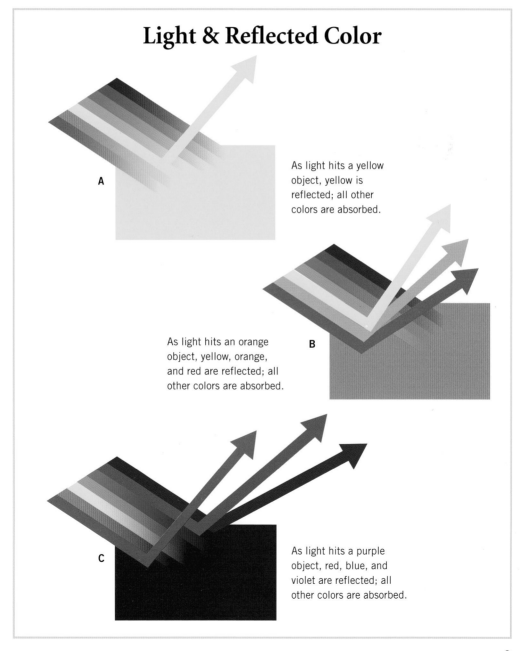

Light & Reflected Color

A As light hits a yellow object, yellow is reflected; all other colors are absorbed.

As light hits an orange object, yellow, orange, and red are reflected; all other colors are absorbed. **B**

C As light hits a purple object, red, blue, and violet are reflected; all other colors are absorbed.

Opacity & Pigment

When light waves strike a surface coated with a layer of paint, they are affected by the pigments' degree of transparency, translucency, or opaqueness. Each pigment has its own specific attributes that affect how it interacts with light waves. A pigment particle's degree of opacity correlates to its ability to scatter light waves. For example, the high opacity of titanium white or yellow ochre is largely responsible for its ability to hide anything beneath it—even dark colors. When the light waves hit a highly opaque layer of color, the particles block the light penetration and the waves bounce off without interacting with the underlying colors or substrate (painting surface, such as canvas or paper). Translucent colors, on the other hand, absorb some light and reflect some back; therefore, they are influenced by the surface beneath the paint.

It is wise for artists to have some knowledge of the pigments they are using—and how light interacts with them—to have greater control over the outcome of their work. For more on translucent and opaque pigments, see "Pigment Properties," on page 30.

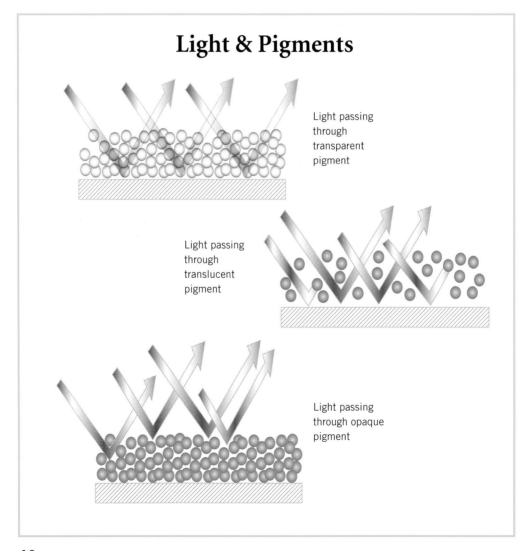

Light & Pigments

Light passing through transparent pigment

Light passing through translucent pigment

Light passing through opaque pigment

Organic &
Inorganic Pigments

Pigments are organized into two main categories based on their origins: organic and inorganic. "Organic" or "modern" pigments are synthetic and very translucent. In other words, light waves are able to penetrate the translucent paint film and reflect the surface below back to the eye. The light waves, in essence, are not obscured by the pigment particles. Because of their translucency, organic pigments are perfect for staining, glazing, and working in layers. When working in this manner, each layer of color is influenced by the color beneath it, resulting in rich, complex, and saturated hues.

To understand the glazing power of organic pigments and view possible layered combinations, create a glazing chart using the colors in your palette.

Another classification of pigments is called "inorganic" or "mineral" pigments. These are opaque in their basic makeup, so light waves cannot penetrate below the surface of the paint layer to reflect the color of the substrate back to the eye. Because the microscopic pigment particles are dense, light waves simply bounce off the top layer. These opaque mineral colors are less intense in hue than modern colors and are not suitable for glazing.

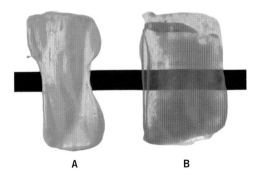

A **B**

View the difference between organic (modern) and inorganic (mineral) pigments as they appear over a black line. The stroke of inorganic yellow ochre acrylic (A) obscures the line, whereas the stroke of organic nickel azo gold acrylic (B) allows the line to show through.

The Color Wheel

Now that we know a little about the science behind color, how do we use our knowledge of light and color to organize a visual system that we can use to achieve our artistic goals? Fortunately, much of this organization has been done for us. The easiest way to view color relationships is through a circular diagram called the "color wheel"—a visual organization of color hues that follow a logical order around a circle. Seeing the colors organized in this fashion is helpful for color mixing and choosing color schemes. Many accomplished colorists throughout history, such as Wilhelm Ostwald, Dr. Herbert Ives, Sir Isaac Newton, and Albert H. Munsell, developed their own variations of color charting, but the 12-hue wheel pictured here is the most common model used by artists today.

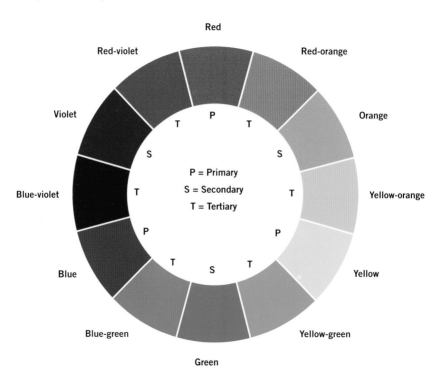

Primary, Secondary & Tertiary Colors

The color wheel helps us see relationships between primary, secondary, and tertiary colors. The wheel's three primary colors are red, yellow, and blue, which are positioned at three evenly spaced points around the circle. The three primary colors are so named because they can't be created by mixing any other colors on the wheel. We can create a multitude of other colors by combining red, yellow, and blue in various proportions, but we can't create the three primaries by mixing other colors.

This color wheel is further broken down into three secondary colors: orange, green, and violet. You can create these colors by combining two of the primaries. For example, red and yellow produce orange, blue and red produce violet, and yellow and blue produce green. Also shown in the color wheel are six tertiary colors, which are created by mixing each primary color with its neighboring secondary color. These colors include red-orange, yellow-orange, yellow-green, blue-green, blue-violet, and red-violet.

Complementary Colors

Complements sit directly opposite each other on the color wheel. For example, red sits opposite green, blue sits opposite orange, and yellow sits opposite violet. These colors are considered "opposites" in their hues and hold the maximum amount of color contrast possible. Just as white is considered the opposite of black, red is the opposite of green. When mixed together, they form a dull gray, brown, or neutral color. Below are a few tips for effectively using complementary colors in painting.

- To lower the brightness or intensity of a color, add a little of its complementary color.
- When next to each other, complementary colors appear brighter and more intense.
- The shadow color of an object often contains the object's complementary color; for example, the shadow of a green apple contains some red.
- Complements are often used in a painting's color scheme; one complement serves as the dominant color, and the other serves as a secondary or focal point color.

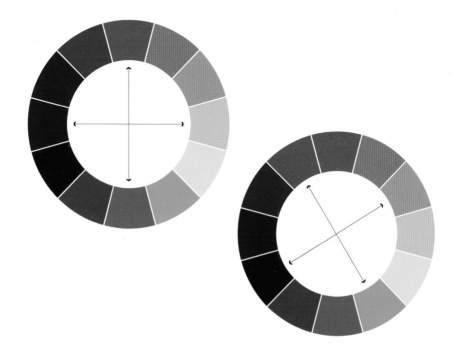

Hue, Saturation & Value

Hue, saturation, and value are three characteristics that help us describe and categorize a color. For instance, if we say an object is red, is it an orangey red or a crimson red? Is it brilliant or muted? Is it light or dark? With an understanding of these common properties, you can identify and describe any color.

Hue

The beauty of the color wheel is that it shows us the relationships between the various hues. The term "hue," which is often used interchangeably with the word "color," refers to the family to which a particular color belongs. Rose, burgundy, magenta, and candy apple red are all in the red hue family. Chartreuse, leaf green, and seafoam are all in the green hue family, and so on. In essence, when one uses the word "color," one is referring to its hue. For the purpose of simplification and logical organization, the color wheel features 12 basic hues.

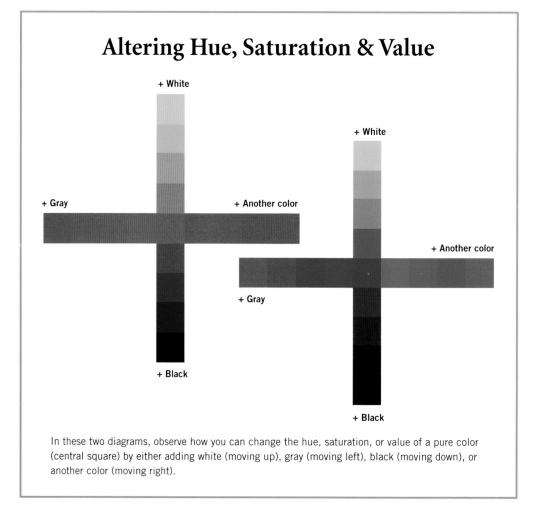

Altering Hue, Saturation & Value

In these two diagrams, observe how you can change the hue, saturation, or value of a pure color (central square) by either adding white (moving up), gray (moving left), black (moving down), or another color (moving right).

Saturation

A color's saturation, also called its "intensity" or "chroma," refers to its level of brilliance or dullness. A highly saturated color is very vibrant. Examples of highly saturated paint colors include quinacridone magenta, phthalo blue, or cadmium lemon yellow. These very bright colors stand in contrast to colors like yellow ochre, burnt sienna, or red oxide, which have a much lower saturation level.

Many beginners who strive to create brilliant, colorful paintings work with a palette of only—or mostly—highly saturated colors. This can defeat their purpose, however, because when too many brilliant colors are placed together in the same painting, they cancel each other out. Each color competes for the viewer's attention. An effective way to use saturated color is in conjunction with unsaturated color, so that some parts of the painting demand the attention while others fade back and play supportive roles. Be aware that if you place a saturated color next to a duller color, the saturated color will appear even more brilliant. This is a very easy way to intensify your colors—simply surround them with neutral, grayer hues.

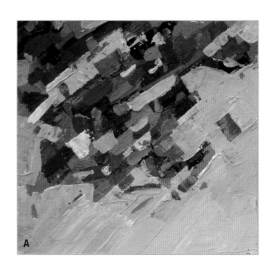

A

B

Brilliantly saturated colors (A) and muted tones (B) can be lovely on their own, but often the key to a successful work is a balance of the two (C). With that said, every artist has a unique preference for color and should select colors based on his or her artistic vision.

C

Value

Value refers to a color's lightness or darkness. A yellow hue is a light value, sometimes called "high key" value, whereas purple is a dark or "low key" value. Every color has a corresponding value, which can be altered by mixing in a darker or lighter color. As you paint, be aware of the values of your colors in order to create dynamic contrasts of light and dark within your artwork.

Viewing a color in grayscale, without the distraction of hue, can help you assess its value. You can also judge the values of your colors by squinting your eyes. Squinting helps you view the world through the darkening filter of your eyelashes, which desaturates colors and helps you see only their relative lightness or darkness. To help you understand the concept of value without regard to color, create a 10-step value scale using black and white paint, as shown below.

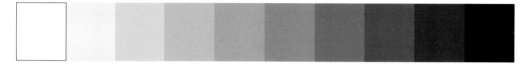

To create a value scale, sketch 10 adjacent rectangles and apply white paint in the box at far left. Then add increasing amounts of black paint to your white paint until you reach pure black in the box at far right. Focus on creating an even gradation from light to dark. You can use the scale as a reference when judging the values of your painting subject and paint mixes; simply hold your scale next to the subject or mixed color, squint, and find the closest value on your scale.

You'll often find that bright, saturated colors appear to be much higher in value than they actually are. For instance a brilliant cadmium red light appears to be a bright, light value. However, dab a bit of it on a neutral gray background and squint: You'll see that it's actually a middle value. This is the optical illusion of saturated colors.

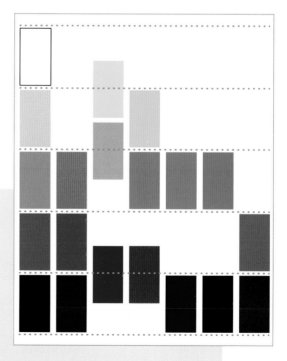

The chart at right shows approximately where standard palette colors fall on a simplified 5-step value scale. (Note that values may vary depending on the brand.) Colors from left to right, top to bottom: cadmium red light, cadmium red medium, alizarin crimson, cadmium lemon yellow, cadmium orange, quinacridone magenta, cadmium yellow medium, raw sienna, burnt sienna, cerulean blue, ultramarine, cobalt teal, phthalo blue, permanent green light, and phthalo green.

Tints, Shades & Tones

Although the 12-hue color wheel shows us color relationships, it does not show the various levels of color saturation and values that are possible. We need to know how to make a color lighter or darker without changing its hue, as well as how to desaturate a color while maintaining its value. This leads us to tint, shades, and tones. A *tint* is a color plus white; when painting with opaque pigments such as oils or acrylics, simply add white paint to any color to create a tint. A *shade* is a color that has been darkened with black paint. A *tone* is a color that has been mixed with black and white (or gray). Most colors we see in nature are tones; very few are full-intensity hues.

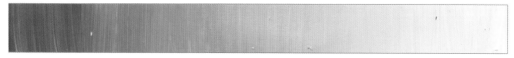

Tints Examples of common tints are sky blue, ivory, peach, pink, and lavender. Shown here is blue with increasing amounts of white, resulting in a gradation of tints.

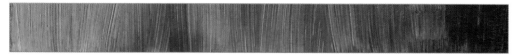

Shades Examples of common shades are olive green, maroon, brown, forest green, and navy blue. You can make any color a shade while maintaining its hue with the exception of yellow; you will find that yellow and black create a green hue. Shown here is green with increasing amounts of black, resulting in a gradation of shades.

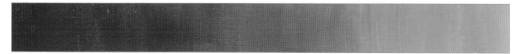

Tones Shown here is red with increasing amounts of gray, resulting in a gradation of tones. The hallmark of an experienced painter is the ability to incorporate tones in a manner that enhances only the most important color of the piece.

Alternative Color Wheel The 12-hue color wheel we have referred to thus far shows colors in their pure form, but it neglects to show the many possible variations *within* a color. This alternative color wheel incorporates tints, shades, and tones.

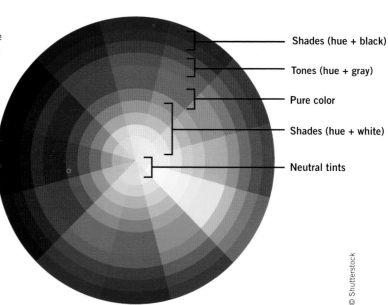

- Shades (hue + black)
- Tones (hue + gray)
- Pure color
- Shades (hue + white)
- Neutral tints

Color & Value

Value provides the foundation for how our eye "reads" a painting. The darks, lights, and midtones work together to create a map that allows us to quickly and easily discern the major shapes and patterns of a scene. Variations in value tell us what is in shadow and what is in light, giving form to objects as well as depth to scenes. Without a range of values, a painting can appear flat, lifeless, and uninteresting. Now that we have given so much credit to value, how exactly does it relate to the colors we choose for a painting?

Because value is the true workhorse of the painting, you don't have to use predictable, accurate colors to create a pleasing scene. In fact, as long as all the correct values are in place, you can use whatever colors you wish (so long as they work harmoniously with one another). Value essentially liberates your color palette—you'd be surprised at the exciting color combinations that can yield successful, easy-to-read results!

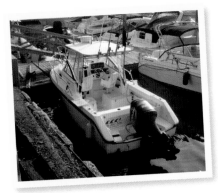

In these examples above and at right, notice how the colors of the painting are much more dynamic than those of the reference photo. Because the images share the same value pattern, the colors don't interfere with our ability to perceive the subject.

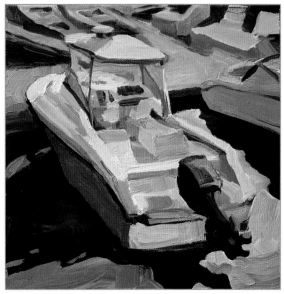

Rye Marina Boat, acrylic

Gloria, oil

You can apply exaggerated colors to any subject, including portraits. Notice how I painted the side of the model's face with turquoise, purples, greens, and other colors that are not typical flesh tones. As you experiment with colors, make sure they correlate to the proper value range. Any part of a subject that is struck directly by strong light will always be lighter than the areas in shadow. If you make you light-struck areas darker (or as dark as) your shadows, the painting will lack proper depth and dimension.

Apple Value Study

Follow this exercise to get in the habit of assigning three values—black, white, and gray—to depict your subject and composition. Experiment with various value combinations and see which arrangement creates the most pleasing light, middle, and dark shapes. Pay attention only to the "big areas" of your subject—don't bother with detail! This exercise will teach you how to design—the most important element in a successful painting. Once you have value "maps" to work from, experiment with color options. Use whatever colors you want—just make sure they are the correct values!

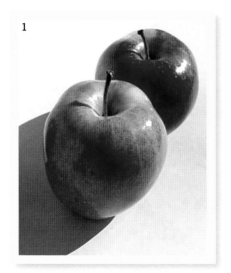

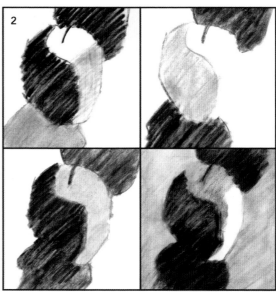

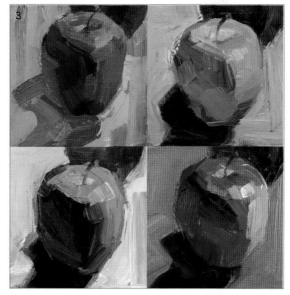

1. Choose a simple subject, such as these apples. Make sure your subject is partially in light and partially in shadow.

2. Interpret the values of your composition in four different ways to create a "value map," swapping middle and dark values to create pleasing arrangements.

3. Following your value sketches like a map, paint your subject four times using the colors of your choice. Squint often and compare the values of your colors to the values of your sketch. Bright, vibrant colors can seem to be lighter than they actually are; squinting will help you see value more clearly. Another method for judging color values involves mixing on a middle-gray palette. This will help you see whether a color leans light or dark.

Four Apples, **acrylic**

Accurate Values, Feisty Colors

As we've discussed, you can essentially assign colors in a painting to match the value map you've worked out. Follow the demonstration below using these unconventional (but aesthetically pleasing) colors in a barn scene.

Color Palette

- Burnt sienna
- Cadmium orange
- Cadmium yellow light
- Cadmium yellow medium
- Carbon black
- Light magenta
- Phthalo green
- Quinacridone magenta
- Teal
- Ultramarine blue
- White
- Yellow ochre

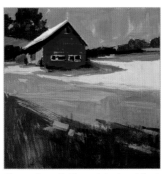

Shown here is the original painted scene featuring a dynamic value pattern and realistic hues. Now we'll paint the same scene using different colors that match the value sketch.

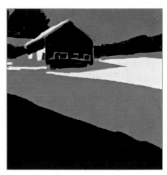

Above is a three-value sketch of the scene using black, white, and gray. This will help you keep your values in check as you choose and mix colors for the painting.

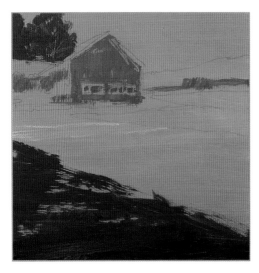

Step 1 Use a large brush to cover your canvas with strokes of a bright, warm pink. Once dry, sketch the scene on top and block in the darkest values with variations of blue.

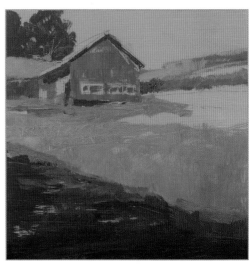

Step 2 Add greens and browns to block in the midtone field and hills. Keep your brushwork loose as you stroke in the direction of grass growth.

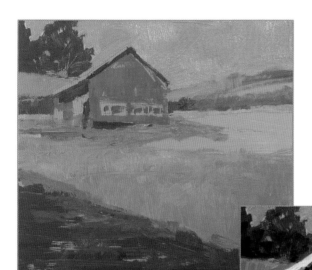

Step 3 Then paint the midtone sky with a purple mix, allowing some of the pink from step 1 to show through for interest.

Step 4 Now add the lightest areas using cool yellow tints. Finish by defining a few details, such as the window sills.

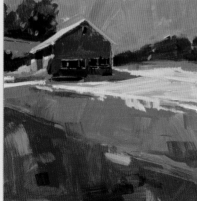
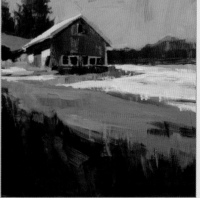

Above are alternative color schemes that adhere to the same general value pattern.

Color Temperature

Artists often call colors "warm" or "cool." This refers to whether a color lies on the red/orange/yellow half of the color wheel or the blue/green/purple half. The color wheel can be divided down the middle into these two groups, as shown at right. The warm side symbolizes the colors of sun and fire, whereas the cool side is associated with ice, water, and sky. Paintings that are predominantly warm and predominantly cool exude a very different feeling based on these associations.

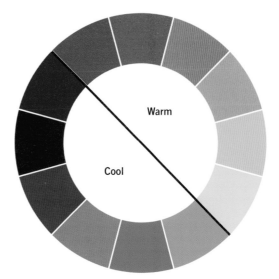

Warm colors appear to come forward in a painting, and cool colors appear to recede. An easy way to remember this is by recalling how mountains take on an increasingly blue or purple cast as they recede into the distance (part of a phenomenon called "atmospheric perspective"). Many artists use this idea to create a sense of depth in their paintings by pushing and pulling elements, using cool tones to push back and warm tones to pull forward.

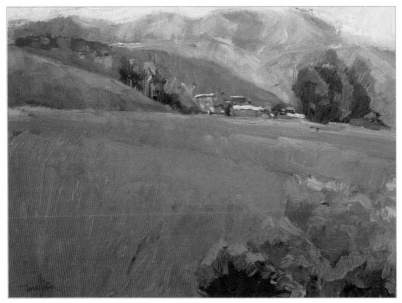

New Mexico Field, acrylic

In *New Mexico Field*, I used the principles of atmospheric perspective to create a sense of depth, pushing the mountains into the distance with cool purples and bringing the near foliage forward with warm oranges and yellows. Notice how even the bushes in the foreground suggest depth with the use of warmer and cooler mixtures of green.

Color Relativity

While colors are generally classified as warm or cool, they can also be *relatively* warm or cool within their hue. Although red is considered the warmest color, there are cool reds and warm reds. A cool red contains more blue (such as magenta), and a warm red contains more yellow (such as coral). By virtue of the relative warmness or coolness of a color, artists can manipulate space and influence how the viewer perceives a color. This leads us to the importance of color relationships. The way we perceive a color's characteristics is relative to its surroundings. By using contrasts in temperature, value, and chroma, we can make colors appear warmer or cooler, lighter or darker, and brighter or duller simply by the colors we place next to them.

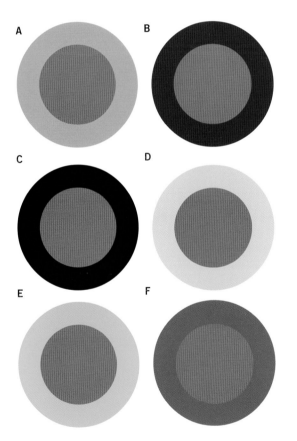

Relative Temperature A color's temperature is influenced by surrounding colors. Note how the same pink circle appears cooler set against orange (A) than blue (B).

Relative Value Our perception of a color's value depends on its surrounding color. Note how the same pink circle appears lighter in example C than in example D.

Relative Chroma A color's chroma can appear different depending on nearby colors. Note how the same pink circle appears dull against yellow (E) and bright against gray (F).

To summarize:
- How do you make a color appear warmer? *Place a cooler color adjacent to it.*
- How do you make a color lighter? *Place a darker color adjacent to it.*
- How do you make a color appear brighter? *Place a duller color adjacent to it.*

Color Schemes

Over time, certain color combinations have been established as especially agreeable to viewers. These combinations consist of two or more colors that have a fixed relationship on the color wheel. This includes tints, tones, and shades of the colors within a scheme; simply be aware of the balance of warm to cool hues, as well as saturated to neutral colors. The following color schemes are most commonly used a basis for a successful painting.

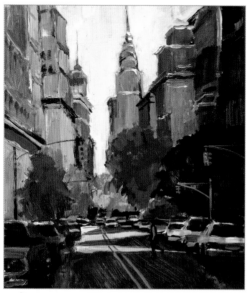

Chrysler Building, acrylic

Monochromatic Scheme The monochromatic color scheme uses a single color throughout, along with variations of the color's shades, tints, and tones. While it's not known to be the most exciting color scheme, a monochromatic palette is elegant, easy on the eyes, and soothing. This is the easiest color scheme to create; all you need is your color of choice, black, and white paints.

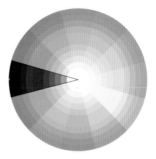

Analogous Scheme The analogous scheme is made of colors that sit adjacent to one another on the color wheel. Most often, one color serves as the dominant color, with others used to accent and enhance the overall scheme. Although the lack of contrasting colors yields a simplistic look, this scheme—like the monochromatic—has a simple elegance that is pleasing to the eye.

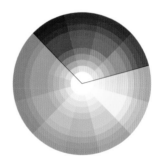

Orange on Pink, acrylic

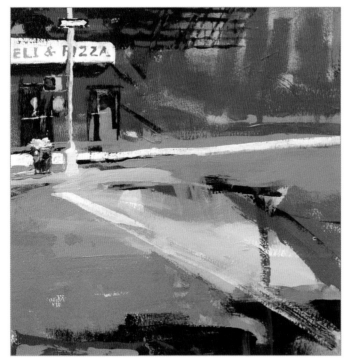

Deli & Pizza, acrylic

Triadic Scheme The triadic color scheme uses three colors equally spaced around the color wheel (for example, red-orange, blue-violet, and yellow-green). Many artists enjoy using this scheme because, unlike the previous two, there is ample color contrast and a natural color balance. One color serves as the dominant color, while the other two act as subordinate hues.

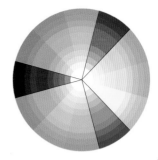

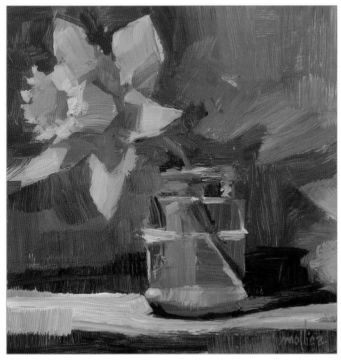

Daffy, acrylic

Complementary Scheme The complementary scheme offers the most visual contrast because it is made up of two colors that sit opposite each other on the color wheel. It is most successfully used when one color acts as the dominant color with the other in a supporting role. The two colors should not be of the same saturation intensity and must be visually balanced. For example, in the painting at left, the subdued purple takes up the most space of the painting but is balanced by the more saturated yellow of the flower.

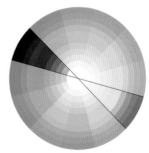

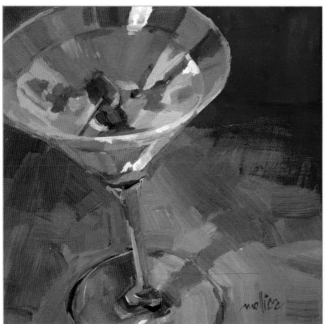

Moonshine Mama, acrylic

Split Complementary Scheme

The split complementary scheme uses a color and the two colors adjacent to its complement (for example, red, yellow-green, and blue-green). This scheme still features good color contrast, but it conveys less tension than the complementary scheme.

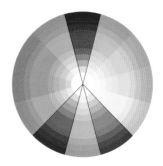

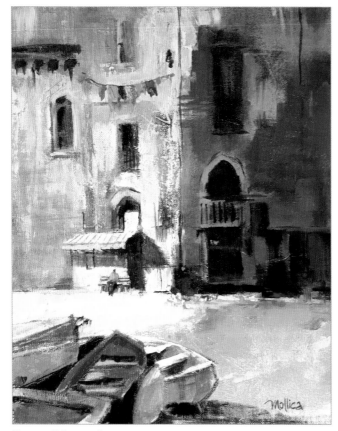

Vernazza Colors, acrylic

Analogous Complementary Scheme

This scheme combines the analogous and complementary schemes, incorporating three side-by-side hues plus the complement of the center color (for example, red, blue-green, green, and yellow-green).

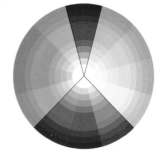

Tetrad Scheme The tetrad color scheme uses two hues that are separated by one color on the wheel, plus the complement of each hue (for example, red, green, orange, and blue). Because this scheme can overwhelm with visual tension, it's a good idea to choose one dominant color and accent with the rest.

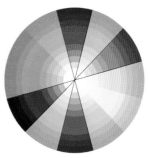

Field and Sky, acrylic

Saturated Scheme The saturated scheme uses the brightest colors possible, with very few neutrals or grays. While yielding a very lively painting, the scheme makes creating a focal point (or area of interest) a challenge, as all the colors compete for attention. (For more on focal points, see page 53.)

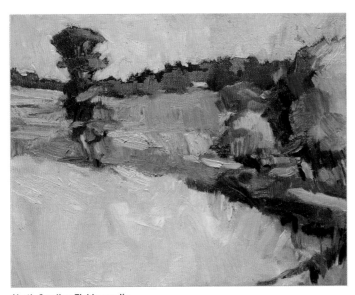

North Carolina Fields, acrylic

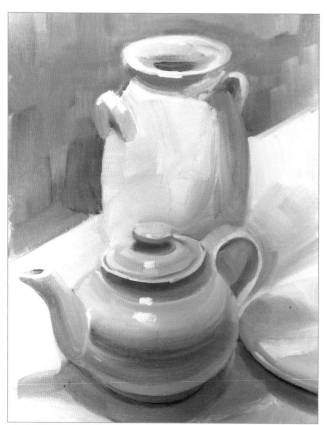

Neutral Scheme As the opposite of the saturated scheme, the neutral scheme uses colors that have been grayed down. This diffused palette is perfect for foggy landscapes, white-on-white subjects, and scenes with a soft, mellow mood.

White Teapot, acrylic

Saturated & Neutral Scheme A scheme of this nature pairs highly saturated colors with various shades of gray. Because much of what we see in life is actually some form of gray, this scheme is often the most accurate way to depict color.

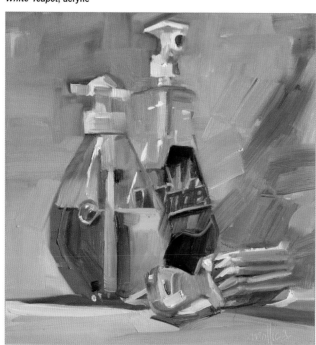

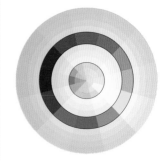

Blues Brothers, acrylic

Mineral vs. Modern Pigments

As we discussed in Section 1, pigments are classified into two groups based on their origins. Pigments are either derived from the earth (called "inorganic" or "mineral" pigments), or they are created synthetically in a chemical laboratory (called "organic" or "modern" pigments). Although they share some similar characteristics, the makeup and behavior of mineral and modern pigments are very different. Knowing their unique characteristics will help you make more effective color mixing choices.

Mineral pigments have earthy-sounding names like sienna, ochre, cadmium, cobalt, and ultramarine. They are generally characterized by
- high opacity (very opaque)
- low chroma (less vibrant)
- low tinting strength (do not strongly change the colors they are mixed with)

Modern pigments have names that allude to their chemical origins like quinacridone, phthalo, hansa, dioxazine, and anthraquinone. They are generally characterized by
- high translucency (very transparent)
- high chroma (very vibrant)
- high tinting (strongly change the colors they are mixed with)

When using oil or acrylics, use mineral colors if you want to completely cover the surface or color beneath, and use modern colors if you want to glaze and allow the surface or color beneath to show through. You are not limited to choosing one or the other; you can mix mineral and modern paints together to achieve greater color subtleties and nuances.

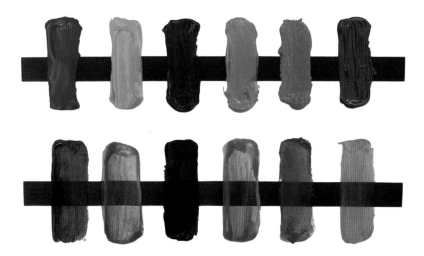

This acrylic paint chart illustrates the difference in opacity between mineral pigments (top row) and modern pigments (bottom row). Paint names on top, left to right: ultramarine blue, cobalt teal, cobalt violet hue, yellow ochre, cadmium red light, and burnt sienna. Paint names on bottom, left to right: phthalo blue (red shade), green gold, dioxazine purple, nickel azo gold, napthol red, and transparent pyrrole orange.

Pigment Properties

Following is a list of the most common paint colors and their properties. All swatches feature the color in acrylic painted thickly over black (left) and the color mixed with titanium white at a ratio of 10:1 (right). Below each swatch, the color was applied very thinly to show its undertone.

Ultramarine blue: This beautiful blue leans towards red. It is fairly transparent with an average to good tinting strength and mixes well with all other colors.

Phthalo blue (green shade): This is a very strong deep blue with greenish undertones. It is transparent and a powerful tinting color; use it in very small amounts because a little goes a long way. When mixed with white, it resembles cerulean blue—a lovely turquoise hue.

Phthalo green (blue shade): This cool, deep green has blue undertones and high tinting strength.

Cadmium yellow light: This cool yellow leans blue and is very opaque and bright.

Cadmium yellow medium: This red-leaning deep yellow is warm and opaque.

Yellow ochre: This muted, opaque yellow-brown is great for darkening.

Alizarin crimson: This cool, slightly bluish red with a smoky glaze creates deep, dense purples when mixed with ultramarine blue.

Quinacridone magenta: This is a very versatile, bright, cool red that is almost fluorescent. It mixes beautifully with blues to create lovely semi-transparent violets and combines with yellows to create bright, clean oranges.

Cadmium red medium: This warm-leaning red is considered a true "fire engine red" and is versatile in color mixing.

Burnt sienna: This dense, warm brown has dark orange undertones.

Burnt umber: This deep, earthy chocolate brown has red undertones.

Bone or ivory black (optional): Instead of using a black out of the tube, such as bone or ivory black, many artists opt to mix their own colorful blacks for a livelier result. (See page 36.)

Titanium white: This dense, bright white offers excellent opacity.

In theory, you can create all your secondary, tertiary, earth, and gray colors by mixing your primary colors. However, many artists like to include tube earth tones on their palettes, such as burnt umber, burnt sienna, raw sienna, and yellow ochre, to create dark yellows and mute colors that are too brilliant for their tastes. The previously listed colors provide a great starting palette for a beginner. Using a limited color palette is the best way to learn about colors and color mixing. Many beginners tend to buy a tube of every color that appeals to them, but this can result in paintings that lack unity and color harmony.

Color Mixing

Understanding the various properties of colors and paints—from hue and color temperature to pigment opacity—gives us the power to combine colors effectively on the canvas. With this foundation in place, it's time to further explore the art of color mixing.

Mixing for Vibrance

We've learned that mixing complementary colors together yields neutrals, grays, and browns. Now we need to learn the basic ideas behind mixing secondary and tertiary colors according to our needs, whether vibrant or muted. To achieve the most saturated, brilliant secondary and tertiary colors, mix colors that *lean* toward each other. For example, you can mix a vibrant purple using ultramarine blue (which leans red) and quinacridone magenta (which leans blue). Mixing phthalo blue and cadmium red yields a completely different result, as they both *lean* yellow. Because yellow is the complement of purple, the mixture is naturally muted.

Note the differences in chroma between the secondary acrylic mixes at right. On the opposite page, you'll find a color wheel to help you create the cleanest, most vibrant mixtures of primary colors based on the direction they lean. (For more on color mixing, see page 34.)

The acrylic mixtures at right show an example of vibrant mixing and an example of dull mixing for each secondary color—purple, green, and orange.

Vibrant

Less Vibrant

Quinacridone magenta (leans blue) + ultramarine blue (leans red)

Cadmium red light + phthalo blue (both lean yellow)

Phthalo blue (leans yellow) + cadmium lemon yellow (leans blue)

Ultramarine blue + cadmium yellow medium (both lean red)

Cadmium red light (leans yellow) + cadmium yellow medium (leans red)

Alizarin crimson + cadmium yellow medium (both lean blue)

Vibrant Mixing Chart

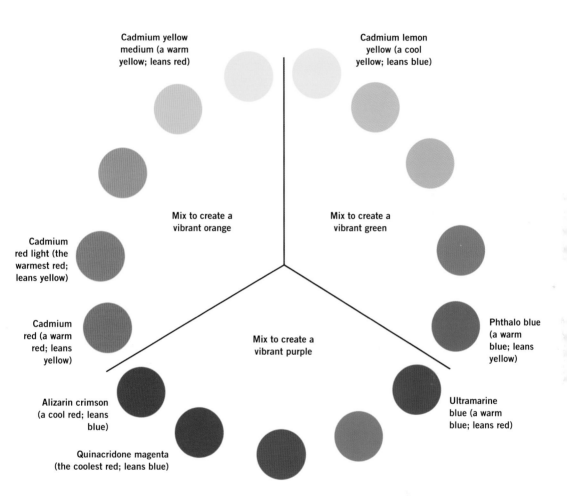

Cadmium yellow medium (a warm yellow; leans red)

Cadmium lemon yellow (a cool yellow; leans blue)

Mix to create a vibrant orange

Mix to create a vibrant green

Cadmium red light (the warmest red; leans yellow)

Cadmium red (a warm red; leans yellow)

Phthalo blue (a warm blue; leans yellow)

Mix to create a vibrant purple

Alizarin crimson (a cool red; leans blue)

Ultramarine blue (a warm blue; leans red)

Quinacridone magenta (the coolest red; leans blue)

To mix the most vivid secondary and tertiary colors from primary colors, use colors within the boundary lines of the pie chart above. For duller mixtures, use primary colors that lie outside of the lines.

Color Mixing Samples

Using the paint colors we have covered, I have compiled some of the most vibrant secondary and tertiary color mixes possible. Practice mixing these oil and acrylic colors on your own and refer to this as a guide when creating your own work.

Vibrant Secondaries

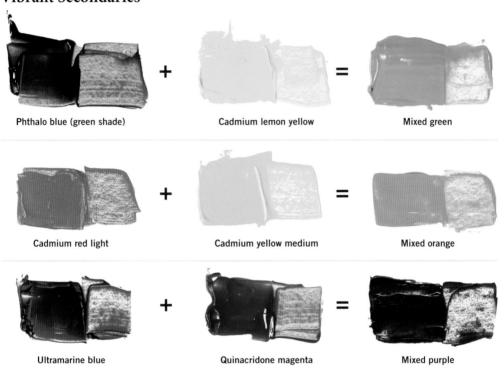

Phthalo blue (green shade)	+	Cadmium lemon yellow	=	Mixed green
Cadmium red light	+	Cadmium yellow medium	=	Mixed orange
Ultramarine blue	+	Quinacridone magenta	=	Mixed purple

Using a Palette Knife

The palette knife is a useful tool with a handle and a flexible blade that allows you scoop, flatten, and mix paint on your palette. You can also use a palette knife to apply paint to your canvas. Many artists create paintings using only palette knives; they apply the paint as if they are frosting a cake. This will result in a thicker, richer application of paint and produces a very different look than a paintbrush does. I prefer metal palette knives with a diamond shape and point at the tip. This allows me to create fine lines and detail, such as branches, sailboat masts, telephone lines, and so on.

Vibrant Tertiaries

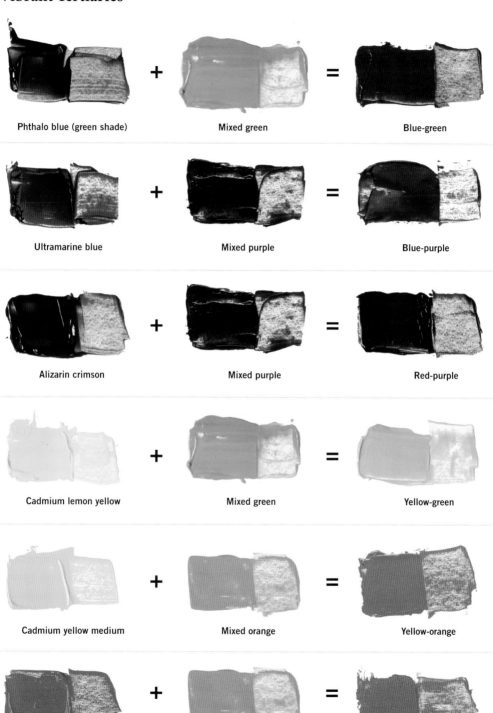

Phthalo blue (green shade) + Mixed green = Blue-green

Ultramarine blue + Mixed purple = Blue-purple

Alizarin crimson + Mixed purple = Red-purple

Cadmium lemon yellow + Mixed green = Yellow-green

Cadmium yellow medium + Mixed orange = Yellow-orange

Cadmium red + Mixed orange = Red-orange

Creating Darks & Blacks

Adding black paint to your colors to darken can appear to deaden your colors. So how do you add darks to a painting in a manner that still looks colorful? Many artists combine the darkest colors in their palettes to create "colorful darks." For example, combining alizarin crimson, ultramarine blue, and phthalo green results in a very dark color that possesses hints of other colors. Your darks can lean blue, green, purple, or whatever hue suits your taste and your painting. This colorful approach keeps the dark areas from looking flat and lifeless. If desired, you can even add a touch of white to bring the darks away from black. Below are examples of my favorite black mixes using the colors in my palette.

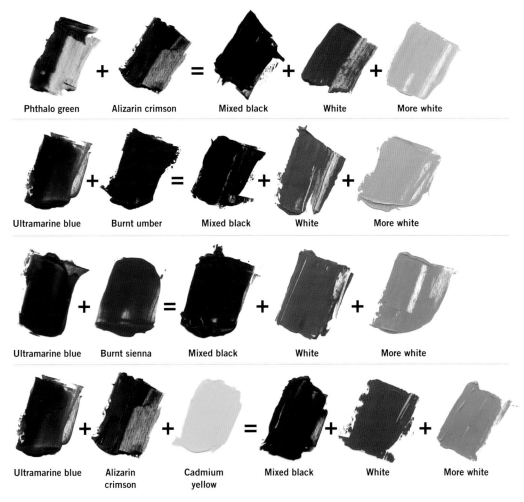

| Phthalo green | Alizarin crimson | Mixed black | White | More white |

| Ultramarine blue | Burnt umber | Mixed black | White | More white |

| Ultramarine blue | Burnt sienna | Mixed black | White | More white |

| Ultramarine blue | Alizarin crimson | Cadmium yellow | Mixed black | White | More white |

artist's tip

Many experienced artists keep a pile of mixed gray on their palettes and add it to all of their color mixtures—except the colors they want to be most vibrant. This ensures a sense of color unity and helps beginners avoid the common trap of "too many bright colors" in their paintings.

Mixing Colorful Grays

Mixing complementary colors can also result in many beautiful "colorful grays" that can help us balance out areas of intense color in a painting. A colorful gray is one that has an identifiable hue identity, such as slate blue or khaki green. Below I have mixed several complements in varying degrees so you can see the many beautiful shades of gray possible. Complete this exercise yourself, mixing your complements in varying proportions to see the subtle colors that will result.

Begin with a simple color wheel using green, blue, violet, red, orange, and yellow. Add a small amount of each complement plus white as you work your way toward the center of the wheel.

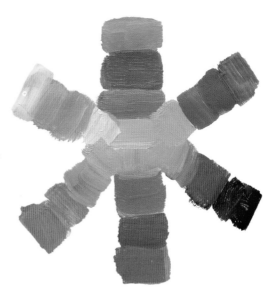

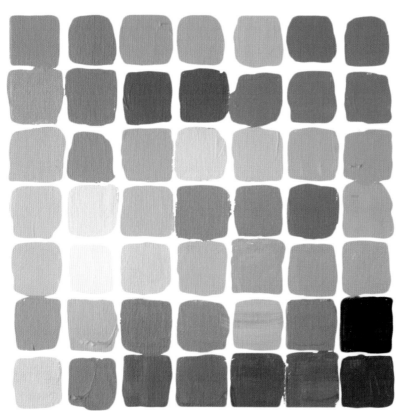

To see even more colorful gray possibilities, a good exercise involves mixing varying proportions of all four of the following colors: phthalo blue, cadmium lemon yellow, quinacridone magenta, and titanium white. Don't feel compelled to spend time recording all the proportions in each mixture; simply experiment and have fun with this exercise. You will be amazed at the array of beautiful muted grays you can create!

Mixing Greens

A typical lush countryside scene can appear to be 95 percent green, leading landscape artists to a common dilemma: How does one paint so much green and keep it interesting? Through close observation, you will notice many variations of greens within one landscape. Compare the foreground to the background, the shadows to the highlights, and the trees to the foliage. You cannot mix all these greens simply using a tube of green paint plus white or black. On the opposite page is a chart that showcases a wide variety of mixed greens: bright green, blue-green, yellow-green, gray-green, brown-green, and so on. You'll find that dynamic greens are possible using a tube green, such as phthalo green, plus a variety of colors in your palette.

Try the exercise shown on the opposite page. Using the colors in your palette, create a chart that shows the various green color combinations possible. Notice that I incorporated complementary red hues in the chart; you can expand on what I've done by mixing in various shades of pinks, lavenders, grays, and so on to create more green variations. You can also tint the resulting colors with white for even more possibilities. After this exercise, you will never again look at a landscape and think "it's just green!"

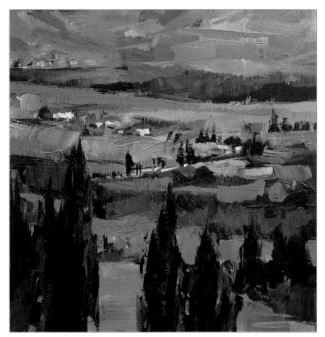

Tuscany Valley, acrylic

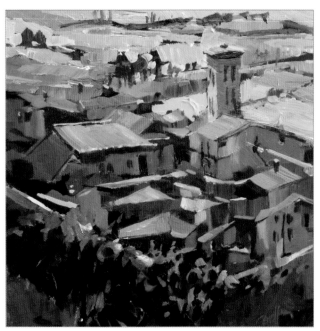

Cortona Village, acrylic

The greens in a landscape can range from rich, dark blue-greens and bright, light yellow-greens (top) to soft, muted tints and tones (bottom). Use your full palette to uncover the variety of greens available to you.

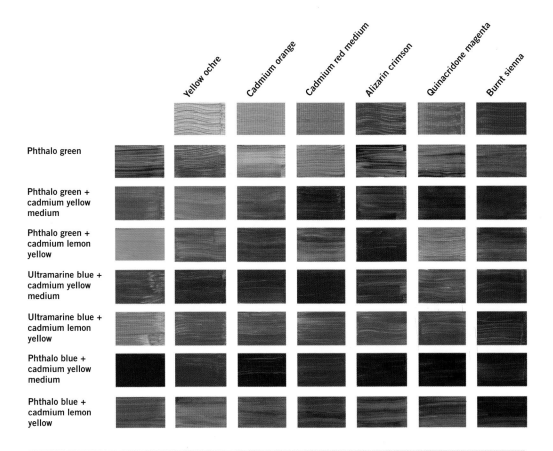

Yellow ochre Cadmium orange Cadmium red medium Alizarin crimson Quinacridone magenta Burnt sienna

Phthalo green

Phthalo green + cadmium yellow medium

Phthalo green + cadmium lemon yellow

Ultramarine blue + cadmium yellow medium

Ultramarine blue + cadmium lemon yellow

Phthalo blue + cadmium yellow medium

Phthalo blue + cadmium lemon yellow

artist's tip

As objects recede into the distance, they become grayer and bluer, as shown in the detail of *Tuscany Valley* (below left). If you want foliage to appear closer, use warmer greens toned with red, orange, and yellow, as shown in *Cortona Village* (below right).

Mixing Flesh Tones

Flesh tones vary widely across the board, but certain color combinations simulate the flesh tones of various nationalities and ethnic groups. It's a good idea to learn what general colors you can produce using your palette. Below are the paints I use as a foundation for mixing a wide variety of skin tones. (Note that I used white in most mixtures.) To create the sampling below, I experimented with the ratios of colors used, basing my results on what looked most natural to my eye. If a mix appeared too vivid, I lightened with white or toned down with a complementary color. Experiment on your own and discover the variety of flesh tones at your fingertips. On the opposite page, you'll see a variety of skin tones in context.

Below are tube colors that I frequently use to mix flesh tones.

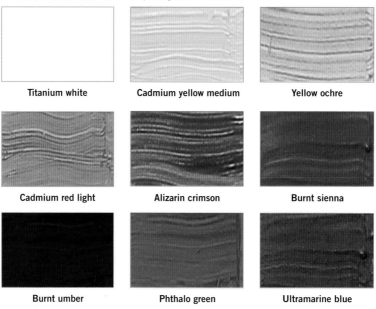

Titanium white	Cadmium yellow medium	Yellow ochre
Cadmium red light	Alizarin crimson	Burnt sienna
Burnt umber	Phthalo green	Ultramarine blue

Below are mixtures of tube colors that I frequently use to create flesh tones.

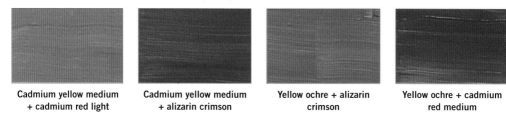

Cadmium yellow medium + cadmium red light	Cadmium yellow medium + alizarin crimson	Yellow ochre + alizarin crimson	Yellow ochre + cadmium red medium

Add these mixtures in small amounts to "gray down" flesh tones that are too bright.

Phthalo green + white	Ultramarine blue + white	Ultramarine blue + alizarin crimson + white

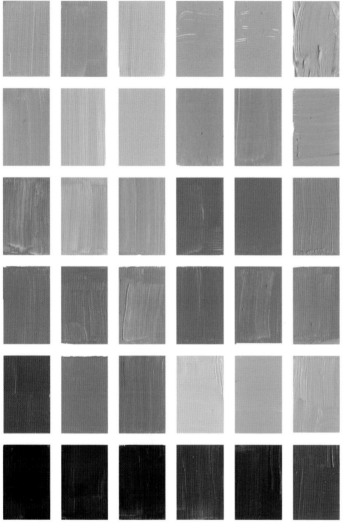

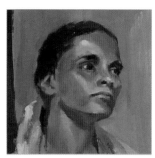

Aqua Scarf, oil, by Patti Mollica

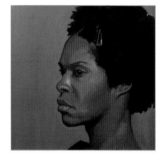

Allison, oil, by Mark Hagan

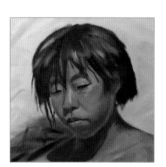

Aika, oil, by Mark Hagan

Above is a sampling of flesh tones I created using the colors on the opposite page. Note the beautifully subtle pinks, browns, yellows, olives, and peaches. These swatches of color don't represent all of the possibilities—there are many more shades waiting to be created!

artist's tip

Flesh is often affected by reflected light from a person's surroundings. Don't be afraid to tone down your mixes with light blue, lavender, and light green, which can offer interesting hues.

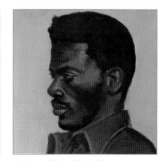

Jordan, oil, by Mark Hagan

41

Painting Light & Shadow

When painting an object's light and shadow, you are not only describing the object—you are also communicating about the environmental influences. Lighting conditions can evoke feelings that suggest everything from mood to time of day and even seasons. The long shadows and warm, golden hues of late afternoon feel very different than the cool, diffused light of a stormy winter morning.

An object is made up of three basic parts: lights, local color, and shadows. The local color of an object refers to its actual or natural color, without taking lights and shadows into account. When approaching a painting, begin by considering the color of the light source, whether it's the sun, moon, artificial light, or candlelight. A bright, sunny day illuminates the light parts of an object with a warm, yellow cast, and the parts of the object in shadow appear cooler. In contrast, the lighting conditions of a gray, wintery day influence an object's illuminated parts to include some cool tones, and its shadows appear warmer. Simply stated, the general rule is this: *Warm light yields cool shadows; cool light yields warm shadows.*

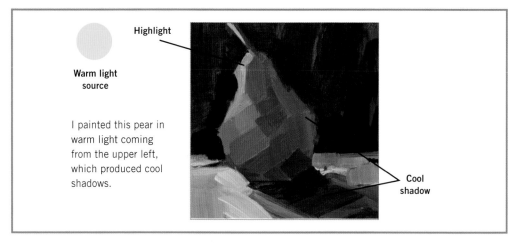

Warm light source

Highlight

I painted this pear in warm light coming from the upper left, which produced cool shadows.

Cool shadow

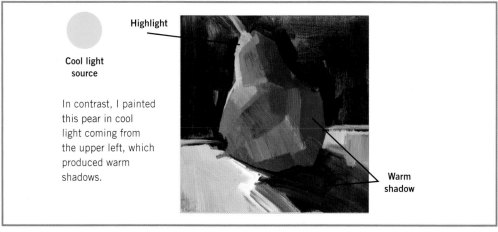

Cool light source

Highlight

In contrast, I painted this pear in cool light coming from the upper left, which produced warm shadows.

Warm shadow

Many artists handle the color of light and shadow using simple formulaic approaches. Beginning painters often add white to lighten and black to darken an object, but there are much more authentic ways to simulate the colors and dimensionality of an object in light. Below are three common approaches. While these formulas are helpful, avoid using them as a replacement for actual observation.

- Add a touch of yellow or orange to all parts of a subject struck by warm light, along with blue or purple to all areas in shadow.
- Create the shadow color by adding the local color's complement. For example, when painting the shadow side of a red apple, add deep green to the local color (red). However, this results in dull shadow colors.
- Use hues that are adjacent to the local color on the color wheel—either lighter and warmer or darker and cooler. For example, use orange and yellow hues for the sunlit side of a red apple, along with crimson and purple shades for its shadowed side. This approach, which results in more vibrant light and shadow colors, is called analogous lightening or darkening. (See visuals below.)

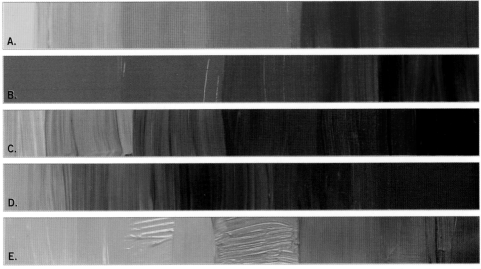

In each example, I have lightened and darkened a color analogously. In row A, I have lightened orange with yellow and darkened it with red. In row B, I have lightened crimson with warmer reds and darkened it with purples. In row C, I have lightened a middle blue with yellow-leaning blues and darkened it with red-leaning blues. In row D, I have lightened green with yellow and darkened it with yellow-leaning blues. In row E, I have lightened yellow ochre with warmer yellows and darkened with browns.

Light Exercise

An artist needs to be sensitive to the color and quality of light in all conditions—from cool, crisp morning light and rosy sunsets to various indoor lighting setups. The best way to learn about the color influence of various light sources is to paint the same subject under several different lighting conditions. Try it yourself and experience the range of effects.

Color & Mood

Color psychology refers to the influence of color on our behavior and perception of the world around us. Although we may not consciously think about it, our perception of color is affected by our gender, age, culture, and ethnic background, among other factors. These differences play a part in how each of us responds to color or color groups. However, there are certain similar universal reactions to color that transcend the individual variables. When choosing a palette or a dominant color scheme, focus on choosing colors that will help you convey the desired mood. Let's take a look at some common colors and their corresponding psychological values.

Yellow Rose, acrylic

Yellow is the cheerful color of sunshine. It conveys warmth, happiness, hope, and positivity. It also exudes childlike simplicity and innocence.

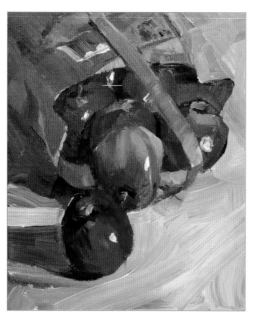

Red Macs, acrylic

A color commonly associated with fire and blood, red conveys energy, power, passion, and love. It stimulates excitement and has been shown to raise blood pressure and heart rate. It is used often in restaurants because it is considered an appetite stimulant.

Pink Brigade, acrylic

Pink is a psychologically powerful color that represents the feminine principle and is associated with love and romance. Pink is thought to have a calming effect, although too much of it is physically draining and can be emasculating.

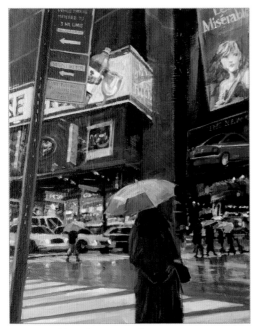

Purple Imperial, acrylic

Purple has long been associated with royalty because only aristocrats could afford the expensive pigment. During Roman times, it took 4 million crushed mollusk shells to produce one pound of purple pigment. This royal color conveys elegance, dignity, and sophistication.

Rainy Day, Times Square, acrylic

When used in light, airy pastel tints, blue is associated with the sky, water, and feelings of serenity, relaxation, and calm. Deeper shades, however, are related to sadness and despair.

53rd and Third, acrylic

The color black (or lack thereof) is associated with fear, death, evil, negativity, formality, and solemnity. Black can be used alongside other colors to make them stand out, and it contrasts well with bright colors.

Mimi's Bouquet, acrylic

As the color of snow, white symbolizes cleanliness, goodness, innocence, and purity. It is considered the color of perfection.

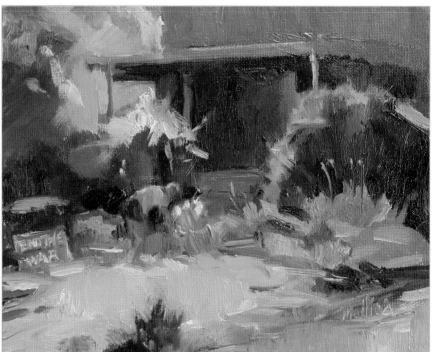

End the War, acrylic

The color of nature, green symbolizes freshness, fertility, and harmony. It is considered the most restful color to the eye and imbibes the cheeriness of yellow with the calmness of blue.

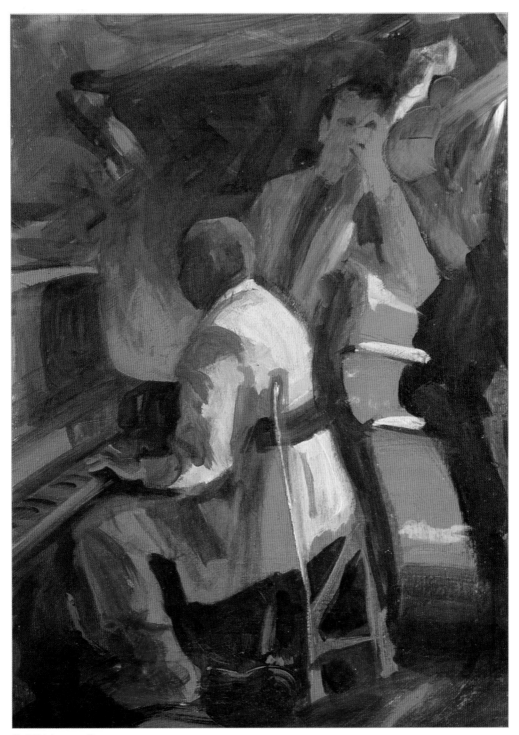

Red Hot Jazz, acrylic

The human eye perceives orange as the warmest color. Orange mimics the heat of a flame and combines the vibrance of yellow with the intensity of red. It represents enthusiasm, creativity, and invigoration.

Color & Painting Styles

Over time, artists develop particular palette preferences and color biases that influence their paintings. Often a palette or color scheme is the most obvious identifying factor of an artist's work over another. Many classically trained artists use color according to rigorous color models and methods passed down over centuries. Other artists use color intuitively, expressively, and according to moods and preferences. Many artists work in a way that falls somewhere in between. In essence, the way each artist expresses through color is a unique look into his or her personality and relationship to art-making. What follows are several common painting styles and their associated approaches to color. Feel free to explore them all and see what suits your personality best.

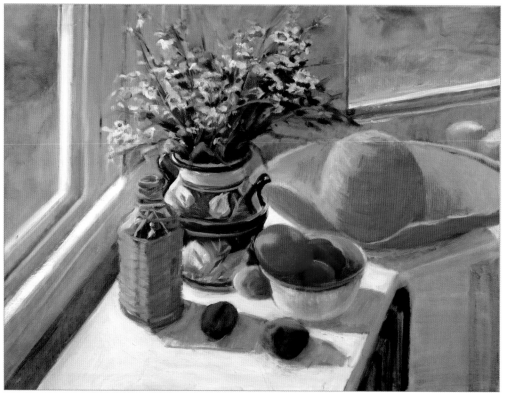

Straw Hat, acrylic

Realist This straightforward style of painting offers an accurate representation of how a subject looks "in real life." There are no distortions of color or proportions, nor is there glorification of subject matter.

Sweet Stuff, acrylic

Painterly This style is similar to realism but celebrates the characteristics of paint through obvious brushwork and texture. Brushstrokes in this style are often made up of paint that has been loosely mixed, giving the paint dimension and creating a more colorful, lively impression, as shown in more detail below.

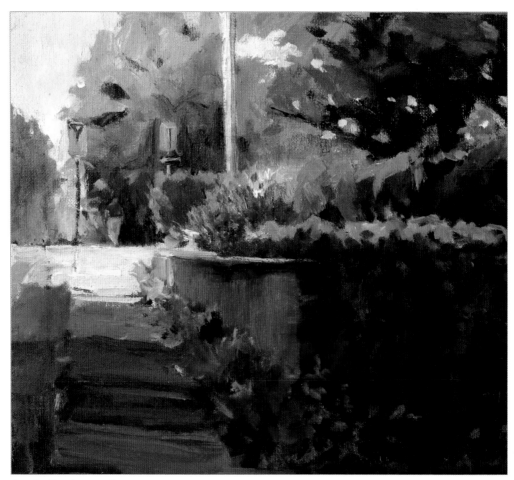

Crossing Broadway, acrylic

▲ **Impressionist** This style originated in Paris in the 19th century and is still very popular today. Characteristics of Impressionist color include optical rather than actual blending. Small patches of color next to each other read as blended color. For example, yellow strokes adjacent to blue strokes create the perception of green. In *Crossing Broadway,* note how the strokes of blues, muted greens, and yellow-greens of the far tree work together to create the overall impression of a tree in light and shadow.

▶ **Non-representational** In this painting style, there is no correlation to any physical subject; the shapes, colors, and textures of the painting are merely for the sake of visual interest. The function of color is simply sensual impact.

Hurry Up and Wait, acrylic

◀ Expressionist This painting style strives to convey mood and emotion based on the artist's feelings about the subject matter. Like Fauvism, there is no need to use realistic colors to simulate the illusion of reality. Expressionists use color to evoke feeling at the expense of recording the subject's actual appearance.

Rooftops in Pink, acrylic

▶ Abstract In an abstract work, the artist simplifies or distorts the subject. The painting maintains a tangible tie to an object or figure. In this style, an artist may choose to relate the colors to the subject (as in the example at right) or use color as a distorting element.

Figure, acrylic

Funky West Side, acrylic

Fauvist This art movement is characterized by artists who wish to express themselves through the use of bold colors, simplified drawing, and expressive brushwork. A Fauvist color palette is extremely high pitched, bold, and uninhibited. This movement paved the way for the Expressionism, liberating modern artists to use color as a valid end in its own right.

Color & Composition

Upon first viewing a painting, you may feel that your reaction to it is based on the subject matter, color palette, brushwork, mood, or style. However, another aspect lurks behind the scenes that may be even more influential on your opinion: composition. This refers to the underlying arrangement of the major abstract shapes, values, and patterns that form a painting's overall structure. A painting can fail or succeed based on its composition and how well it leads the eye around the canvas to the focal point. Color is a wonderful tool for guiding the eye; consider color as it relates to the focal point, sense of contrast, and overall composition of your work.

Focal Point

Begin by thinking of your canvas as a two-dimensional stage of shapes and colors that tells your audience what to notice in a scene. Many beginners place their subjects right smack in the middle of the canvas. While this placement certainly demands attention, it is hardly compelling or exciting. The viewer appreciates being led into the painting and circling around to spots of interest, with a clear path to the focal point. Consider down playing anything that takes the eye away from this center of interest.

Rule of Thirds

The rule of thirds is a guideline for focal point placement. Divide your canvas into thirds horizontally and vertically and note the four points where the lines intersect. Placing the focal point on one of these four areas is known to be pleasing to the eye.

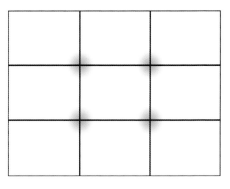

▲ The rule of thirds is a simple way to find an effective spot for your focal point on your canvas. Marked in green are four possibilities.

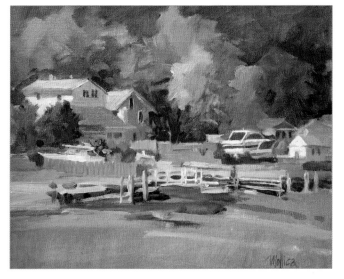

In *Piermont Dock*, the figure in red serves as the focal point and falls on an intersection of thirds.

Piermont Dock, acrylic

Types of Contrast

Once you have established a composition that features your focal point in a pleasing position, you will need to lead the viewer around the painting to the focal point. Since you may have several areas of interest within your painting, you will need to find ways to emphasize the focal point and minimize competition. As in the following examples, the eye will be drawn to the area of strongest contrast, whether it be through value, edge, chroma, or temperature. Let's explore each.

▶ **Value Contrast** An area of dark value next to a passage of light value commands the viewer's attention. Many painters will place the lightest color next to the darkest color within the focal point, such as the white highlight on the dark blue bottle.

Blue Bottles, acrylic

◀ **Edge Contrast** The edges between subjects (or shapes of color) in your painting can range from hard and crisp to soft and blurry. Because the eye is drawn to crisp edges, you can guide the viewer to your focal point by strategically softening and hardening your edges. In this non-representational piece, the focal point is in the lower right quadrant, where the crisp circular edges contrast the softer color changes and strokes of the rest of the painting.

Delta, acrylic

54

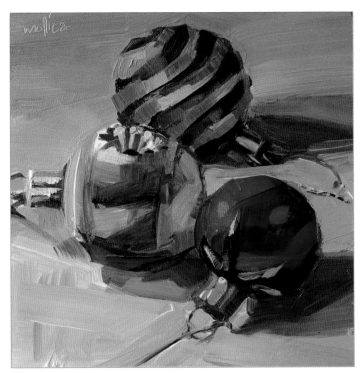

◄ Chroma Contrast
An area of bright, saturated color will naturally demand the viewer's attention when surrounded by less intense colors. In this painting, the high-chroma red and green of the ornaments "pop" against the gray background.

Shirley's Bulb, acrylic

◄ Temperature Contrast
Maximum color contrast occurs when you place complementary colors next to each other within a painting. Because complements involve two colors opposite each other on the color wheel (one from the cool half and one from the warm half), the colors contrast in temperature. You can easily create a focal point by applying a warm color in a painting that is predominantly cool, or vice versa. Note that complementary colors of the same intensity will compete and vibrate, therefore it's best to desaturate one of them. In this painting, the warm, bright red contrasts effectively against the cooler, more muted greens.

Red Spot, acrylic

Personal Approaches to Color

Now that you have learned the fundamentals of color theory and have a grasp on color schemes, mixing, and artistic styles, I will share with you some experiences with color as it relates to my own paintings. Some of my paintings follow a specific color concept that we have covered in a previous section, but other paintings emerged from a more intuitive standpoint. This can be best described as the "throw out the rules and just play with color" approach. While it certainly helps to know color theory fundamentals, the rules should never feel oppressive to the point where you feel creatively stifled. To the contrary, color is a means of expression; use it to communicate your unique vision, preferences, and personality. After all, your artwork is about you! Experiment with the colors you love, and if you run into trouble, use your knowledge of color theory to analyze the possible source of visual discord. The models of color organization we've covered are intended to empower you and your artistic voice—not suppress it.

Into the Light: Working from Shapes & Values

One of the best ways to work freely with color is to use reference material that does not reveal the actual colors of the subject. In this painting, I worked from a low-quality, pixelated black-and-white photo. Because I could not make out any detail, I was able to glean only the main shapes and values. I began by painting the subway stairs a cool red. Why *red?* Why not? Starting off with a color I like felt right, so I went with it. The color choices that followed were a series of reactions to each successive choice; for example, the warm, muted green walls balance the cool, bright red. The deep maroon of the stair wall at left mimics the hue of the steps. These were not conscious decisions but merely impulsive reactions that worked. Taking liberties with color can result in color choices that are far more interesting than reality.

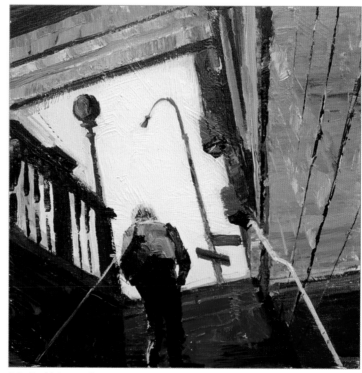

Into the Light, acrylic

Green Flash:
Keeping Your Colors Fresh

When you start looking at everyday household items as still life props, you'll be amazed at the collection you have at your fingertips. This little bottle of iridescent green nail polish is the perfect counterpart to the common pinks and reds in my collection. To keep your paints fresh, particularly when working with complementary colors, it's important to prevent the colors from getting muddy. To do this, I mix a small batch of color on the palette and apply it to the canvas in one—and only one—stroke. The more times you stroke a color, the more likely it is to dull down, lose its freshness, and become overworked.

Green Flash, acrylic

tkts:
Assigning Colors to Values

For this painting, I mixed about six colors that simply looked pleasing together (without heeding the color wheel). As you can see, there is a predominance of warm light values balanced by cool dark and middle values. When planning a composition, remember that it is best to feature one dominant value (light, middle, or dark) while the others play subordinate roles. In this case, the light value takes up the most canvas space, followed by the dark values. The middle values amount to the smallest coverage. As you paint, squinting is the easiest way to assess your values because it filters out color perception.

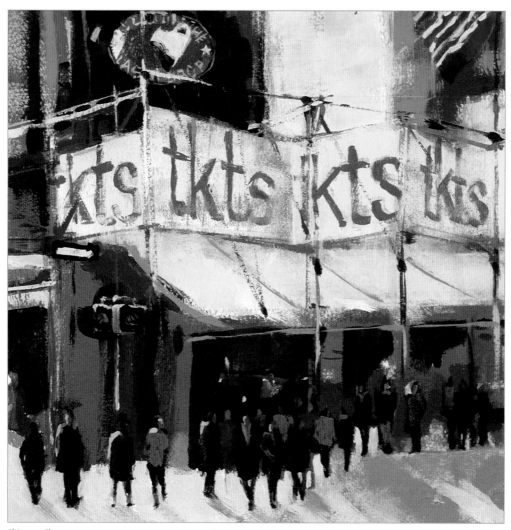

tkts, acrylic

Park off Park:
Using Artistic License

As you can imagine, the streets of New York are not actually teal. But who says they can't be in a painting? For this particular work, I used artistic license to dictate my color choices, choosing teal for the road because it contrasts nicely with the red bricks of the building. Artistic license refers to the freedom you have as the artist. This is where intuition comes in; if you feel something should deviate from reality, go with it and see where it takes you!

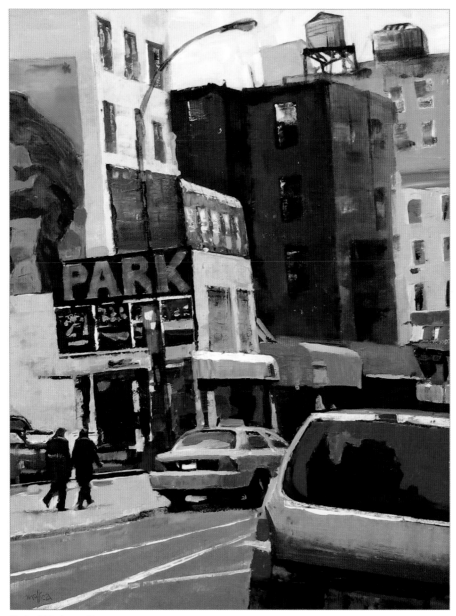

Park off Park, acrylic

Bronx Bound:
Capturing Reality

This painting is about capturing color reality rather than distorting it. What's more real in New York City than a subway train full of weary commuters at rush hour? To emphasize the overall yellow-green cast from the harsh fluorescent lighting, I chose an analogous color scheme of yellow, green, and blue, which unifies the setting and creates harmony out of chaos. When your subject features too many distracting and competing colors, consider adopting an analogous or monochromatic scheme. These simplified approaches to color are easy on the eye and create a sense of harmony. Alternatively, you might also choose to unify your colors with a glaze of a translucent modern color.

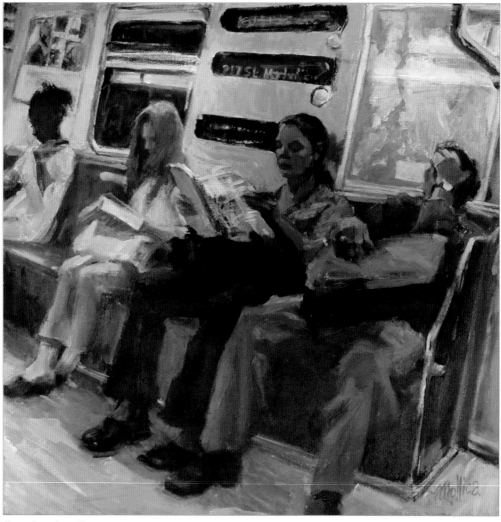

Bronx Bound, acrylic

Nyack Center:
Accenting with Fauvist-Inspired Colors

To express the cheerful mood of a warm, sunny spring day, I chose to accent this piece with a variety of Fauvist-inspired colors—from lime green and turquoise to vibrant reds. Notice how the warm corals and fuchsias in the street point to the cool receding blues and greens of the church. Because the figures are secondary to the street and building, I painted them using low-key colors, which sets them back and unifies them with the dark areas of foliage.

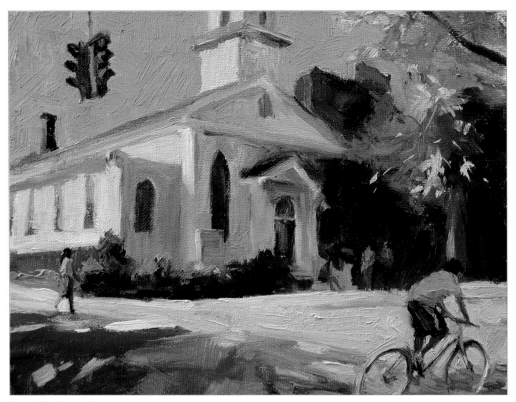

Nyack Center, acrylic

Closing Words

The great colorists of the world did not arrive there by chance; they realized that to fully harness the power of color, one must understand it rationally and logically. Although it's very enjoyable to play with color in a random and impulsive manner, this can easily lead to choices that are discordant and visually jarring, which may defeat the purpose of your painting. Listen closely to your artistic voice, which wants to express freely, while staying mindful of basic color relationships. The best way to balance on this fine line is to fully understand the fundamentals of color theory so that when it's time to create, your knowledge will be a springboard for intuition.

As you learn the fundamentals, study the masters and analyze their color choices. My personal favorite is Joaquin Sorolla—an indisputable master of color. When you have truly done your homework, you will no longer need to reference the color wheel; instead, you will intuitively reach for the colors that best suit your goals. The more you know about color theory, the more you will be empowered to use—or choose not to use—the tried-and-true concepts. As the Dalai Lama says, "Know the rules well, so you can break them effectively." As you go about your days, make an effort to notice all the colors around you—from vibrant, high-chroma colors to subtle and elegant pastels and earth tones. The more sensitized you become to your surroundings, the more fascinated you will become with the vast, exquisite world of color we are so lucky to live in.

Red Cosmo, acrylic

This book is dedicated to Mimi, my buddy and loving companion for 12 years (pictured with artist on inside back flap), whom my husband and I lost recently. Mimi, you filled our lives with laughter, inspiration, and sweetness. We'll miss you forever.